Thoughts
- Sweet and Sour (part-1)

Thoughts
- Sweet and Sour (part-1)

Sanjeev Kumar

PARTRIDGE

To order additional copies of this book, contact
Partridge India
000 800 10062 62
orders.india@partridgepublishing.com

www.partridgepublishing.com/india

for

My

parents

To whom I owe my existence. They would have been very happy to see it.

Preface

The book in hand would never have seen the light of the day had the long felt desire to pen down the thoughts that often came out of the association with the world around I had been a part of, were there.

The notions may serve a few lessons especially to those who never take things seriously and ultimately realize that it is too late now for the time cycle is simply irreversible. The "thoughts" are deliberately not arranged but appear as and when they came to me. Some may agree or disagree with them but let me be true enough for they had been my sole experiences. The idea to put the experiences both sweet and sour was long felt like the journey other's was never very smooth.

But to me, the important is that I could pen them down in the form before you and feel indebted to all had been in the association. With these words, I welcome you all to enter the world of the outlet of emotions in writing.

Sanjeev Kumar

Love your enemy for they remain till the last.

If heart has started bleeding, it should only serve as an 'eye opener' for already enough has been listened to it and therefore, it is time to move up towards your 'head' now.

Those who protect you for your evil deeds, in fact shield theirs.

'Distances' trigger, the moment a confidant concludes, that you are there not for compromise but to impel.

Undeserved "position" leave 'some', never to recover from its hangover even years after since it was taken away.

Willfully letting someone consider you as a 'time pass' for years together, can only mean that unconsciously soft corner had developed which never simply be able to soften the other's.

Your peace of mind is adversely affected by the disturbance in other's.

The shroud that we all have to put on one day,

carry only the scope to take our deeds along.

Even a single wrong entrant in the unit is capable of bringing the genealogy to a deadly halt.

Each' near death experience teach us to grow wiser.

The day they realize that you have understood and therefore, may not remain a toy for them to play with anymore, stop even recognizing, despite decades of association.

The only assets one can never be robbed of, are the sweet memories of the past and the acquired knowledge - both simply cannot be carried off.

It is the obsession and not 'dedication' alone,

that can bring laurels to your priorities.

"Few" could become 'great' not because they achieved greatness alone, but had the caliber to get the same thrust upon them as well.

It is the 'dearth' that make a notion look more charming.

Some 'role-models' soon vanish, the day you meet them in real.

Avoid 'some' who invariably need one to pastime with.

Only the ones need to be pitied the most, who prefer to lose throughout, for they are optimistic enough to make at least 'one' stop playing with his feelings.

The most recreating game that some excel in, is to play with the emotions repeatedly, for they know that they will win simply because the partner in the game is absolutely unaware of the basic feature attached to it-the 'warmth'.

Only a friend can ditch when you need him the most.

The saddest part is that despite being very near, you may not be able to either visit or to guide and boost morale of your own ones, one day.

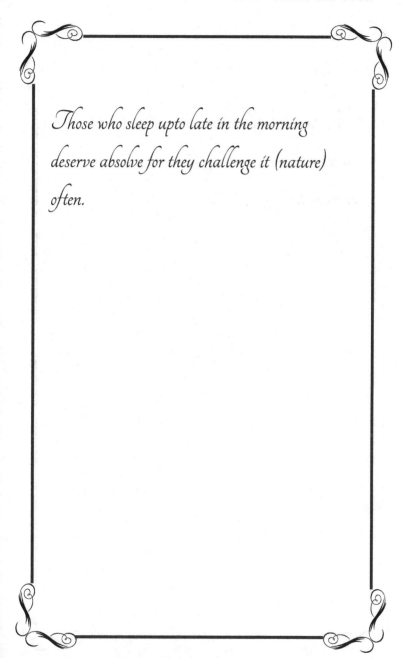

Those who sleep upto late in the morning deserve absolve for they challenge it (nature) often.

It is the class of the 'subservient' and not 'autocrats' that can bring the revolution overnight.

If the journey into the past start working as a lullaby, it can only mean that you miss the same, more than anything else.

The 'scariest' had been the ones who entered saying they came into your life to make it a 'blessing' for it was never their intent.

Close relations are transitory but the distance it precipitates, is far fetched.

'Trust' can yield impeccable results.

When no such adjective - bestest- exists, then how can they (friends).

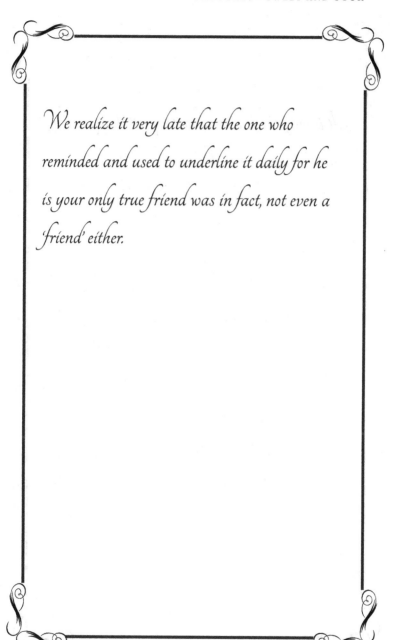

We realize it very late that the one who reminded and used to underline it daily for he is your only true friend was in fact, not even a 'friend' either.

It is only the fear and not 'respect' that go along with the departed soul.

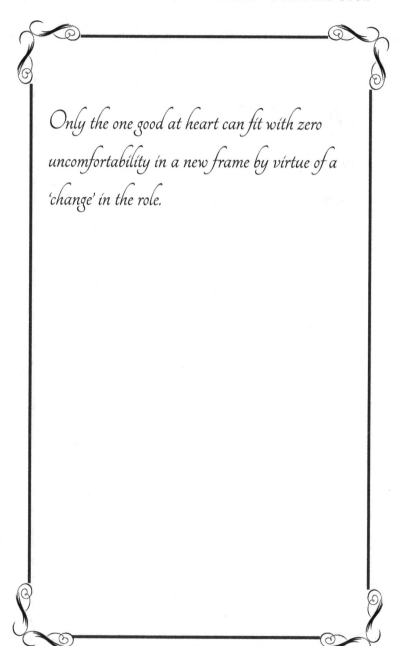

Only the one good at heart can fit with zero uncomfortability in a new frame by virtue of a 'change' in the role.

Parents should never die, for love and the affection you were bestowed upon, also leave with them.

The truth is that GOD loves all. No matter the destiny laid hands on the epitome of your love and affection so early a stage and, therefore the foster treatment is not acceptable at all.

Cannibals are not defunct - rather each has become more demoniac.

Only those who are unfit, aspire to become the fittest and when they fail even to survive, accumulate 'within' ills in multitudes.

We do find Shylock(s) even today who continue to execute the 'bond'(s) as per their whims and fantasies.

A fiend when freed, come in true color that otherwise was suppressed.

Play safe for both the seniority and headship are short lived.

The degree in which 'diabetes' is likely to attack you, can be measured from the amount of sugar, put in by a non sugary person in his behaviour time to time.

Those who enter the second innings after 50, not only deserve compliments but morale boost as well.

No matter what you accumulate on your own, but if it is not an extension to what your forefathers had left-it is worth penniless.

No 'castle' can ever be overpriced than you ancestral shed.

Those who tye you in moral bondings more often than required, infact do so, only to confirm, whether the string of emotions is intact.

The one who yearns for ill-timed monetary benefits, is temporarily insensible that he will lose his also and give only an 'add' to the 'laughing stock' subsequently.

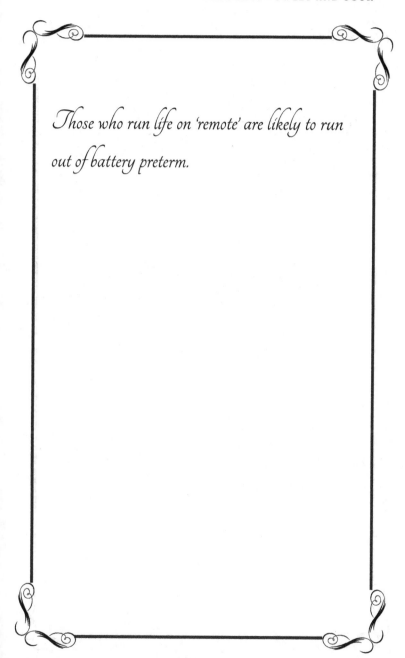

Those who run life on 'remote' are likely to run out of battery preterm.

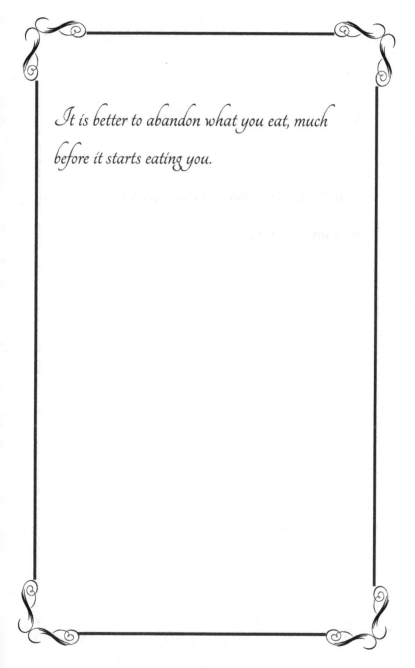

It is better to abandon what you eat, much before it starts eating you.

One time meal is expensive but to some 'immoderate' too, exclusively because of the 'rider' that has been attached to their destiny for never been able to afford the same.

Those who had done nothing except to dupe others by their fake expressions of innocence and treacherous smiles are likely to be exposed irretrievably, one day.

The freedom of bearing the torch should be reserved only with the 'guide', for it is the faith and this gesture of respect that ultimately will take everyone safely to their respective destinations one day.

An 'ill-willed' associate is a nightmare even at daytime.

'Patience' and 'bubble gum' have one very strong and a common feature-both blow off when tested to an unwarranted degree and if each had endured maximum upto 20 mm/20yrs, it speak volumes of their unequalled excellance.

It is the culture at the 'backdrop' that makes the entire difference.

It is not 'history' alone, the characters also keep on repeating - and that too, in multiples.

Opponents never sleep- they delay only to give you a befitting reply.

If second time too, someone else picks up your friends' mobile-it only connotes that he is evading you.

It is the 'money' that had always been the most favorite to 'some' and never the 'person' whom it belongs to.

'Money' may not be able to buy love but certainly can purchase the peace and harmony and a key for survival.

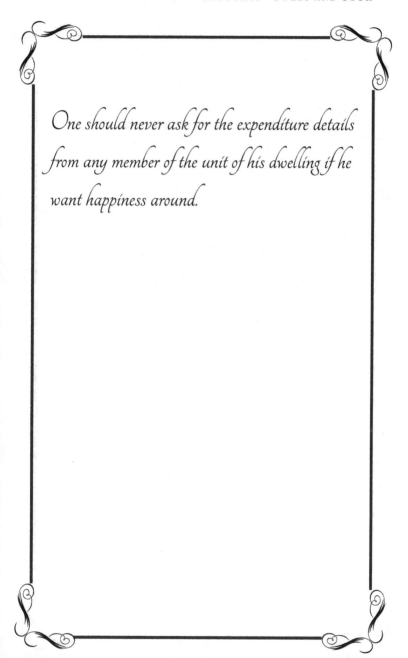

One should never ask for the expenditure details from any member of the unit of his dwelling if he want happiness around.

Tale of 'some' can never be straight.

The only company that frightens you the most is the one whom you are directly attached with- by virtue of a close 'relation'.

Coming back before sunset is important, no matter if it is the affection of your 'pet' that draw you home.

The intentions can be gauged proportionately when one speak, louder than required, for he does it consciously, only you to listen in zero decibel of what others say of him.

No greater sympathy can be drawn toward the ones who fall very easy to the prey by revealing their deepest hidden secrets after they are pampered by others and to be ousted from their hearts soon after.

It is better to resign much before your tenure as 'head of the unit' expires, especially when the members neither inform nor intimate but take you into confidence only to assist them in materializing their designs.

Some are in so a hurry that they neither wait for the time nor tide and ultimately when reciprocated with the same gesture of their's are left with no option but to face the music thereafter.

'Bad time' never gives any even a jiffy where in he can ready himself for the disaster.

Those who run faster then time ultimately are forgotten by it.

Time give you much and that too within 'time' the signal of its arrival, but many deliberately do not listen to its tick tock and therefore, ultimately fail.

Those who precondition, that they may love you, provided you change, were simply never meant to be yours.

Why keep on hunting for a 'correlative' when you were never conferred with any- better focus on other equally important intents that need be urgently addressed to.

Darker is the day when you realize that you had shouldered unconsciously only the burden of 'other's throughout-but the day become the darkest especially when time changes its recourse and 'they' discard you that very day itself.

Need to be empathized with and not envied of the ones who do not relish but waste much of their time / energy in boasting and showing off the gifts they had been facilitated with, leaving always an impression as if they were the chosen nature's prodigies.

'Loneliness' turns out to be your true companion especially when you really need the one.

It is the breath that keep you look lively and beautiful. Once it is gone, nobody will even come near you.

The cost one pay for 'peace' increases in an unimaginable ratio day by day especially when the offspring have crossed their initial twenty springs or so.

How long your life had been, can be better told by the one who had outlived it in the rural world.

It is the crowd of vested interests around that straighten the bone in your neck and make you ultimately spineless.

When you lose, people do not pity you but thank the Almighty for it was not their turn.

It is all O.K. if you day had started with no prickling of conscience of the previous day.

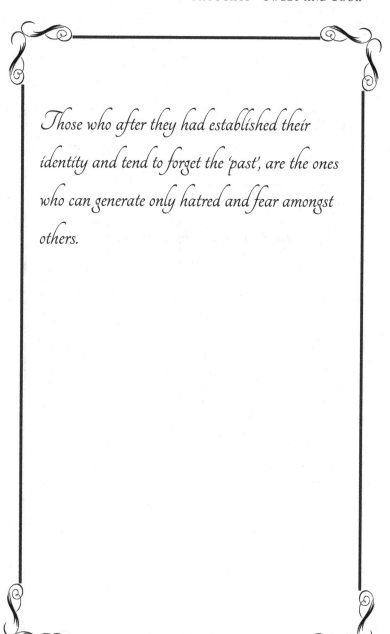

Those who after they had established their identity and tend to forget the 'past', are the ones who can generate only hatred and fear amongst others.

No greater sympathy can be toward the ones with normal abilities, whom people call 'abnormal' and call him mad and 'off-centered' when he try to act according to their definition.

In case, life after death is no better, one can always utilize and depend on the caliber to pen down his emotions - an easy way again to cope up in times of uncomfortably.

Marriages are made in heaven but you are able to find the correct partner is not only a sheer matter of chance but also depend on the efforts you put in to find the same.

Those who say love and care for you will never

inquire of your well-being even in their dreams

to the degree they always claimed, what to say

of paying a visit to the yard they left you at last

and feel your presence at least, once in a while!

To make your 'shirker' opponent work on a project that otherwise is suppose to be undertaken by you can be to just pass upto him the impression diplomatically that the assignment in question had been your ambition for long- and see how this blueprint works.

It is always the next generation that tell the gaps you need to fill up.

Never let anyone know that you have a heart for 'some' may dice with your feelings.

Those who often inquire of their rating on ethical values, in fact are still not clean.

The integrity need to be revisited of those who one fine morning start saying that they of late have lifted themselves spiritually.

It is the 'nature' that ascertain, the cycle gets complete of the 'treatment', by making us the recipient the same of what we meted out to our elders.

The one who subjugates put the other the same time at his mercy for how much will he be attended to, time to time.

And the best award for 'self mockery' goes to-any guesstimate- Yes, you are right-the only and one who had outlived his life by giving everybody an opportunity to enable each for making him 'fool' again the again.

'Communion' can breathe only between the one's promised.

It is the same 'character' who makes a new entry but with a different role every time, only for a 'pay back' due to him.

Only 'roguish' take *HIS* shelter for a hideout.

One may befool 'a few' for some time but not all-every time.

Those who often boast that they follow gentleman's drinking rules, in fact, adopt the same only after a series of incessant bad experiences.

To perceive what the other had concealed underneath the feathers, is a complete venture of itself.

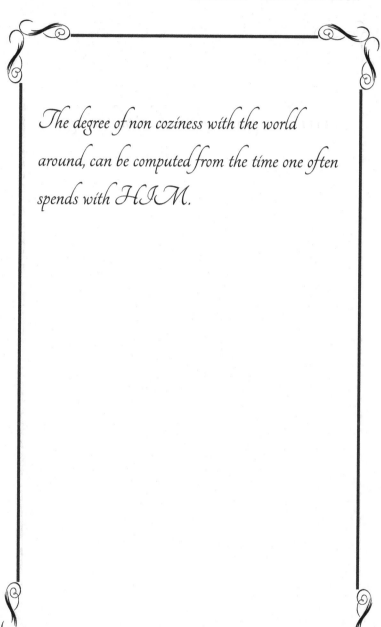

The degree of non coziness with the world around, can be computed from the time one often spends with HIM.

An illiberal is at its worst especially towards his end.

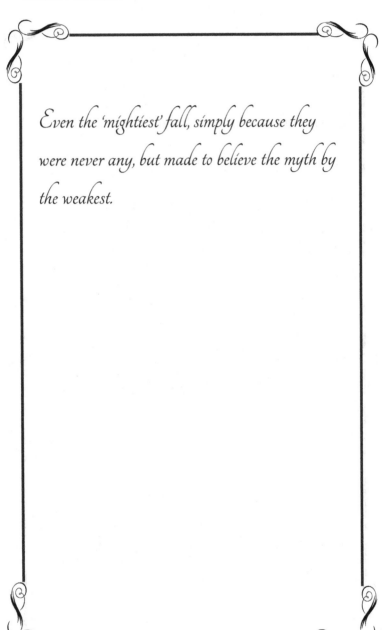

Even the 'mightiest' fall, simply because they were never any, but made to believe the myth by the weakest.

Alike breath, 'uncomfortability' with any also is short lived.

Color of spirituality can overshadow all, provided done on duly washed powers of reasoning.

Some are jack of no trade but master of one (spellbind).

'Predominance' can only attract a shattering blow to correlations.

Disparity amongst some can never be at par.

A deadly beast is unpredictable, if rescued preterm.

'Incompatibility' in the beginning lasts till the end.

Those who claim their expertise on human relationships are never able to maintain any.

Some always grumble that they did not get what they deserved but never endorse the underserved.

It is the fear 'within' that kill you first.

Those who wear innocence in no time are in fact, the most learned persons.

Push off from those who pull each other.

It is the 'pamper' that spoils the person and makes him most indecisive, ultimately.

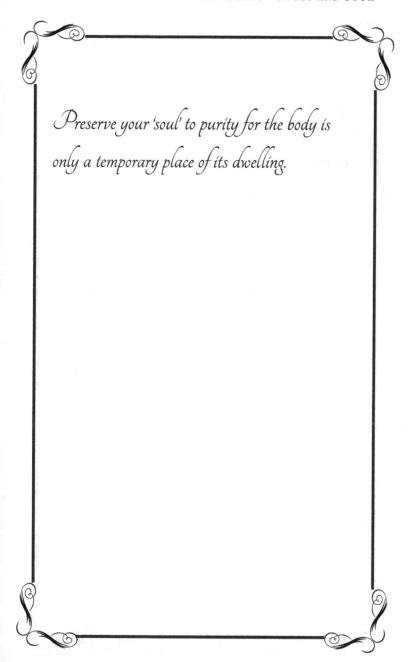

Preserve your 'soul' to purity for the body is only a temporary place of its dwelling.

Inculcating 'fear' way be for a temporary outcome but it houses permanently.

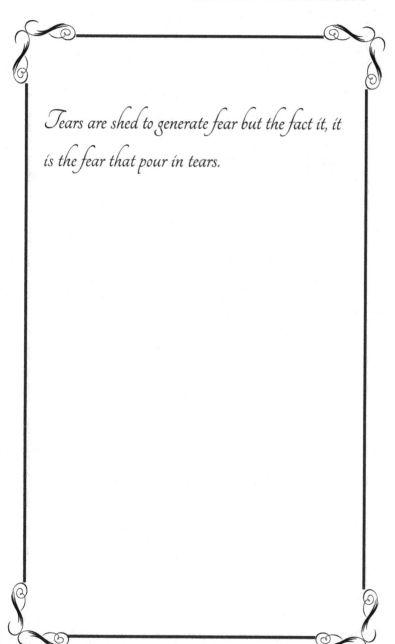

Tears are shed to generate fear but the fact it, it is the fear that pour in tears.

'Some' out to hunt the culprit, kill the innocent when fail to nab the same.

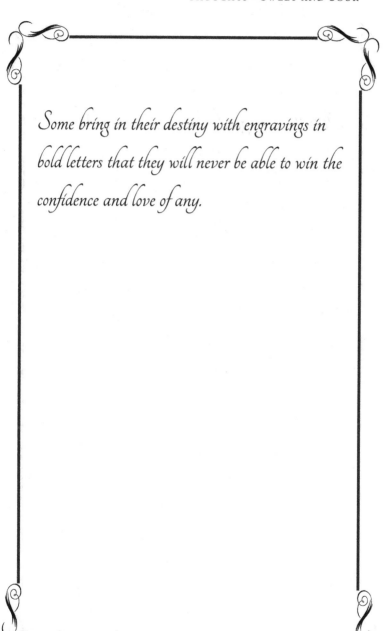

Some bring in their destiny with engravings in bold letters that they will never be able to win the confidence and love of any.

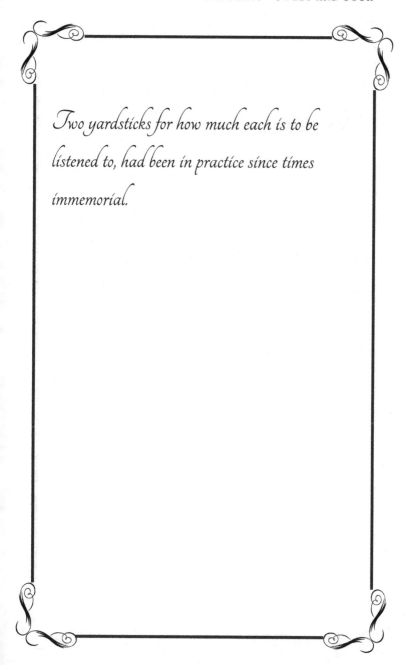

Two yardsticks for how much each is to be listened to, had been in practice since times immemorial.

Those who shed crocodile tears are found to get unveiled in time proportionate, of their treacherous nature as well.

The fraternity with opposite gender nature is a different gentry altogether.

One should ignore/ avoid the show if the trailer is not worthy.

Some are born privileged.

Nearing destination one realize that the only baggage missing is of the moral deeds, simply because he never carried any.

When the other has stopped even giving reaction, it can only mean that the relationship is nearing 'end'.

It is towards the end of the show one concludes that he had only acted alike penny wise pound foolish throughout.

At least, dawn of your life should make you wiser.

All the different unending traumatic phases pass in a flashback when looked retrospectively.

Outside 'books', it is the context at the backdrop that a reference is made and not vice-versa.

All carry with them a voluminous memoir, both sweet and sour, but hardly few are able to share it.

Some introspect only in retrospective terms.

One may win, provided in the next half of the battle the supporters fail to understand that they are being made the 'scapegoats' again.

We love only 'the people with constructive nature', though they work less-maximum upto 18 hrs but never to the ones with 'destructive mindset' despite their working upto almost 48 hrs or beyond in a day.

The most active your opponents are when they are passive.

Don't ever fall prey to people who are ready 24x7 to guide and protect your interests. The fact is that they protect their (vested) interests taking you shield instead.

Be cautious from those who use without adjectives the magical words as "sorry" and "thank you" more often than required, as these expressions keep you always in a dilemma of their being sparingly courteous or repentant, until each have played the final black magic by using the former in the final go.

We regret the loss of our the then precious "present" that we never relished for we did not get what we deserved, until it becomes the "past"-filled with sweetest memories.

The day you realize that not other "parents" were better and your home was not "hell", you had lost both that otherwise were always yours.

Even if we could reduce the number by one or two who would bid you bye from their core of heart on your last destination, that will be an achievement.

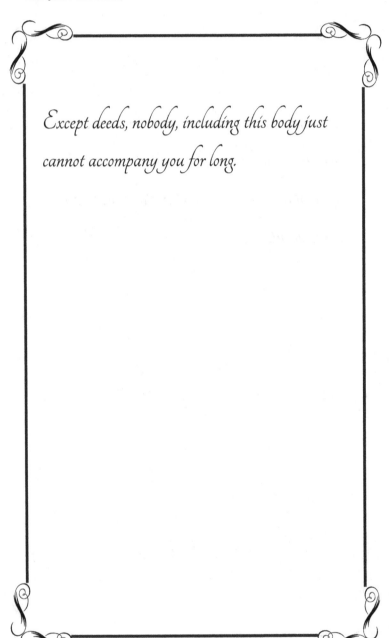

Except deeds, nobody, including this body just cannot accompany you for long.

One just cannot achieve his goal until it becomes
an obsession.

It is not the 'money' but 'modesty' that will make you wealthy.

In practicability, too negative cannot make a positive but too positive make a negative.

The good thing is not that you did, but you believed in yourself.

One day everybody reaches to the conclusion that he never had understood the ways of the world and that nobody took him serious either.

We often lose for we are never told that it was a game.

Every parent dream and work hard to make their child become the fittest of the survivor but he realizes and turns out to be the same is a sheer matter of chance.

Every relationship is a 'Contract', therefore think twice before entering into an 'agreement'.

Life is a blessing but many remain bent on making it a curse till it is taken back.

We prefer to live despite all odds, only to see the end and the suspense attached to every story we had been a part of, as we will remain blissfully ignorant of the same, otherwise.

Undeserved bread and butter is relished but can take generations to get rid of the indigestion, till someone in the lineology one day, decide once for all and prefer to starve than to eat it again.

The five senses of yours can never betray and will complete their term provided you give them complete rest especially during back and off to work the next day.

Most irritating people are the ones who prefer to confuse especially when they do not know the answer and to plead in their defense.

Ones with nefarious nature always excel in manipulation and therefore never run out of resources for its fruition, but even they too, ultimately are handicapped when it comes to maneuver with their life cycle.

'Open book' are the people who can be read but never could be the ones who read only other's.

Self styled 'kingmakers' can only make even kings- a pauper.

Stability make 'some', relatively even better well-skilled shirkers.

When stoops, one speak volumes unconsciously of the ambitions proportionately to do something more reprehensible.

The dream of a well knitted family of yours can turn into a nightmare especially when the co-head of the unit rely unconditionally and have full faith in 'Almighty' and therefore is always relaxed and content doing so.

We confront and come across to the best of our virtuosity and aptitude in the company of 'work shirkers' only.

The price some people give for giving life to young ones get back the same from them @1 day per day.

It is always very late you realize that your parents were the best of all except to underline it in black and white so that it become a testimony.

Each day the world around taught a new lesson and every time I forgot-could never become a good student.

It is very natural to get swayed every time, for one is always told only good and positive traits about him but the repercussions in the long run are negative repeatedly.

Unlike knowledge, the experiences too, will never be robbed of you, for a lot of time and energy had already been spent in acquiring the same and therefore, will always serve as a ready reckoner in both the worlds, in times of need.

The good thing is that it is only a matter of few years not beyond 100 in any case can you be unduly taxed.

'Master-stroke' by the opponents deserves appreciation but the compliments should not make them presumptuous, for the game has not come to an end yet.

There was a time when those who used to stab at the back were labelled as 'friends', but as they do it from the front now-so no reason to get confused as both the 'friend' and a 'foe' have changed their positions with the passage of time.

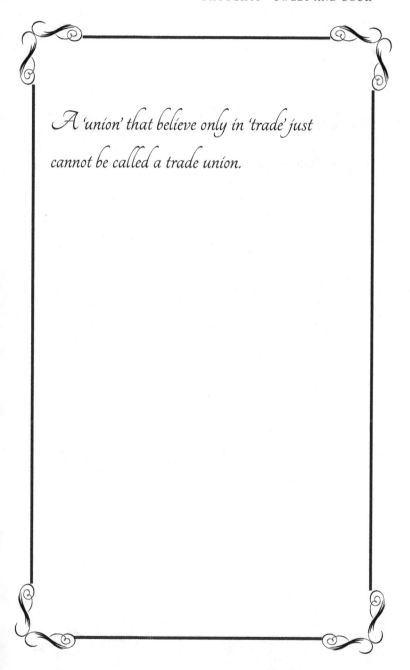

A 'union' that believe only in 'trade' just cannot be called a trade union.

In times of need, alike litmus test, in no time, your friends too, come in true colours.

Even history fail to teach that the number of 'Brutuses' and 'Iagos' also multiply proportionately with the passing of time.

A true 'wire-puller' can be the one who not only make others pull each other, but also to assist him in pulling the wire.

It is not only the 'present' but the 'past' that determines the 'present' as well as our 'future'.

No better criteria to gauge the mastery over the villainous nature can be from the one that every time when caught you escape so cleverly leaving again the other deeply confused and repentant to have doubted your integrity and therefore if pardoned, will never even think and believe whatsoever the circumstances may be.

No greater sin can be from the one to have inculcated only 'insecurities' in your young ones for you were never entrusted for this mischief.

One may walk off to work and meet himself once again the next day, only if he walk in back home and meet only others.

No better shock can be any for those who take themselves to be very excellent in befooling others by the captivating smiles, as one day they realize that the one who fell very easily into their trap schemed the entire show.

Only few could become 'complete' in writing skills as per 'Francis Bacon' for the atmosphere and the required company of the lovers and obsessed persons who believe only in papers always was short lived.

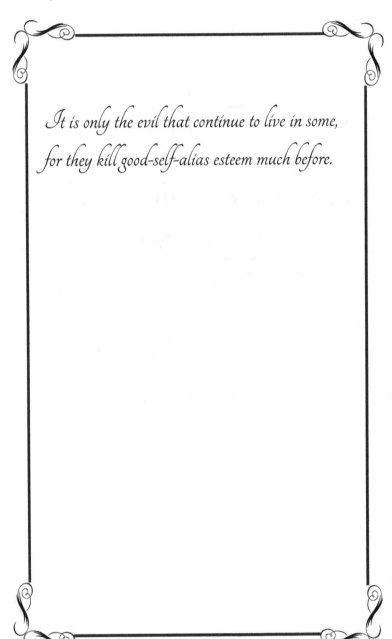

It is only the evil that continue to live in some, for they kill good-self-alias esteem much before.

It is not 'astrology' but the 'present' that can foresee your future.

The enactment of a role becomes more challenging especially when the role of a 'schemer' is played by a failure 'otherwise'.

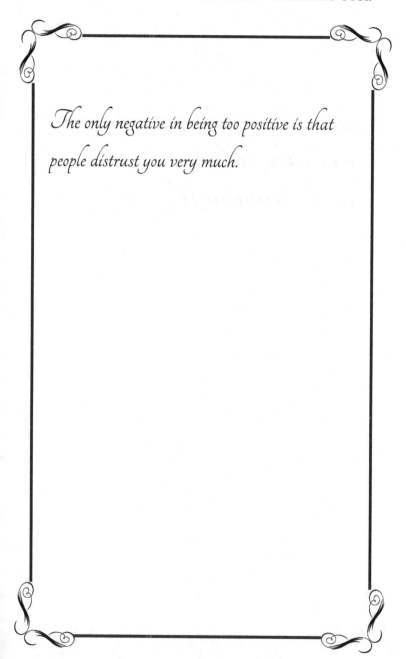

The only negative in being too positive is that people distrust you very much.

There is one very positive attribute of negative mindsets-they give their hundred percent to actualize the maximum of this finesse.

An unreliable confrere and that too with an inherent gloomy outlook is the one who can always befool you again and again.

Lucky are the ones who are ultimately granted the wish to live all alone one day as they were never comfortable in the company of any.

Those who always claimed and reminded that for them you were their only pet (loved one), soon vanishes the day you realize that you were only behaving unconsciously as their "pet" (tamed one) literally, but unfortunately it is sparingly late, for not only you lose your so called 'masters' but your identity as well and that irretrievably.

Only the ones with zero 'esteem' can think of eyeing and ultimately relishing alongwith his look a like the 'bread' which never was meant for them at all.

'Well-wisher' of today wishes you and reminds of being the one only when you are in the well.

Those for whom the synonym of 'worship' is 'work' are the real ones at the mercy of GOD.

The head of the unit fell himself on dialysis pledging for mercy life, for whether young or old, daily keep reminding him that he lack worldly knowledge and that he is not social either- a prerequisite for the same.

You are never listened to, for they take you always for granted, either out of excessive confidence or not an iota of it at all.

'Idiots' have one positive trait-they are adventurous enough and can afford to muddle with the bee hive only for a lively click.

'Gain' without 'pain' do/should not deserve even the remotest thought-towards inclination.

One may afford to add 24 hrs daily to his lifeline, provided he continue posing as 'idiot of highest degree' before all.

We study, struggle, settle down but can remain happy only if we ultimately spend in entirety our worth on those whom we are directly attached. With zero expectation in return.

The imbalance between the deeds and the reward is probably to compensate the variation for the outstanding balance in the previous records.

Sanjeev Kumar

*The more you leave expressions of 'innocence',
the more you get the benefit of doubt!*

Blessed is the 'curse' that complete its due course.

Most unreliable are those self styled leaders who does nothing except politicking.

The one that corresponds in nature, can only be your true companion.

The weight the sword of Damocles carry, is so heavy that the one on whom it is hanging, die many a times before it ultimately kills, irrespective of the sincere efforts one puts in to escape the engulfed deadly virus on it.

The prime objective is irrecoverable if the maiden discussion opens up into new avenues and scope for the battle of words.

'Multi-skilled' can only be the one who is able to hide the other's.

Only the torch bearer can envisage the stability as well as the tremors bound to come on the unit he is leading.

TV and devotion 'within' a dwelling unit are ample to ruin the peace and harmony irrespective of all.

The practice some people do, by dying scores of time daily, ultimately make them so perfect that they die permanently one day.

Only fittest of the survivor can escape even "inneundoes".

The choice for not been able to live can simply be never yours.

Every imprint on childhood is so strong and deep rooted that it can get dissolved only into five elements one day.

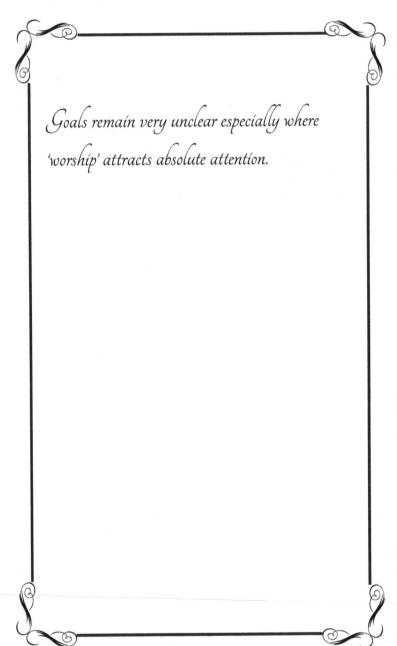

Goals remain very unclear especially where 'worship' attracts absolute attention.

Some breakdowns come so sudden that you never realize for the role you were entrusted with is over quite a long ago.

The species that eat whom they call their own ones, had gone extinct- is a sheer myth, for it still exists and continue to do the same even today.

Arguing with fools proves that the quorum is complete.

Even those who live round the clock with the species of 'snakes' do not trust them for they know that so called masters too, will not be spared one day.

The ship is bound to wreck especially when every passenger starts taking himself to be the captain on the expedition.

We need to pity and not hate the people in whom the evil is able to overshadow the good spirit to the extent that the suggestions every time by the latter starts appearing evil and the opposite.

It is better and one will not die if he eats a meal less than to manipulate more than two by either eyeing on other's share or to earn the same through unfair means, for you become bound to die hundred times and that too, to the extent, that even time may not be able to bring death to the name synonym to 'curse' you earn and therefore not be able to kill it for generations altogether.

Life becomes exceptionally challenging especially when the circle around expertise in the art of mesmerizing to the extent that one fail to understand the ulterior motives as some tom, dick or harry one day unfortunately happen to become our close associate by virtue of a relation, enter with a predestined purpose to destroy and shatter to ruins the dreams our parents ever saw for us.

When you greet someone and he does not respond, but greets only when you start to revert with the same treatment, infact is the person who need to be studied thoroughly before it is too late for you to realize that he has made you fall into a mousy trap again.

Never fall as an easy target to those with a history of a gloomy outlook especially after they have crossed 40, as their mastery over their negative capabilities reaches to a transcendental point where it starts multiplying and that too, with no minutest realization of this caliber to themselves and to others as well.

Distance yourself from those who more than often act sparingly discourteous by being always in a hurry to be the first in every race, no matter how many each has to push aside but surprisingly become exceptionally courteous when it is a final call from 'up there'.

Never blame anybody for they had never any role in your share of happiness as it was foreordained.

It is better to start boycotting those normal
look alike people who behave quite abnormal
and continue with their frantic efforts to run
their social stake for they never get complete
satisfaction until they are ostracized from the
society they live in.

Hats off to our mentor- the tiny 'brain' who lives only to see that we live it hardly ever takes a nap, albeit, always remember its duties apart from the moral ones towards us and our body and despite being over burdened / preoccupied, it also never forgets to take us every night (specially when our body takes a nap so that we enjoy sound sleep) to the places / people whom 'time' had snatched from us, this sleeplessness, however would continue till our body had breathed the last, once the body is dead only then, feeling content of having done the prime duty of safe guarding us from the source of fear, this mind go in deep slumber, leaving us forever with the world of ours which we had always missed.

Our placement in either of the world above will solely depend on the type of certificate / degree, the institution called 'society' we live in confer on us. We may get the hint, if so desired. At the last platform, just look back and see how many have come to see you off.

Life is an exam. Pass it through fair means, there may not be a second chance if booked for "UFM".

Be off the 'radar' of those who desire to relish 'absolute power'- they make you 'spineless' in order to make their's strong.

Try to maintain a distance if not of 'seven seas' but certainly of miles altogether from those who relish aesthetic pleasure and enjoy sound sleep by putting others to displeasure and sleepless night.

Even the time equal to the one we outlived here, will run short 'up there' while sharing / complaining to our people for the treatment meted out to us in their absence by the fellow beings, thus making us feel light, day by day proportionately.

Every passing day reduces 24 hrs from the anticipated waiting time when you ultimately are supposed to meet everyone whom you have lost.

You may look sparingly ugly, but the most handsome to your ultimate beloved, with your brand new best apparel, who owns and take you along, the time the world had discarded.

The art of 'puppetry' can only be in the domain of some.

One may find some friends in the garb of "an enemy" but the number will be many vice versa.

Be extra careful from the one who always smiles.

The number is in the majority, who never do through/ due proper homework in correct direction and put the entire mantle on 'destiny' whenever they fail-call it 'predestined'- taking always the shelter under an old tactics to hide zero or no preparation on their part-but a million dollar question haunts- for how long can one escape from his duties at hand, every time????

Those who stand by Truth are always singled out.

'Modesty' has no harm.

'Insecurities' do not leave even after you are secure.

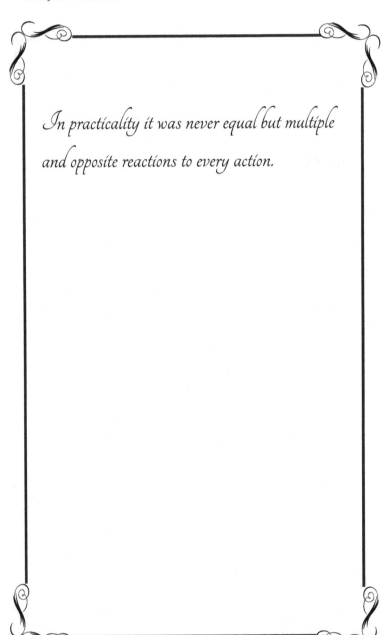

In practicality it was never equal but multiple and opposite reactions to every action.

Children should also promise to the same degree that they will pass the litmus test in the absence of their torch bearers and shall never let down their parents who had promised never to come back.

No greater gift than of 'happiness in life' can ever be and the truth may better be understood from those who try adding it further by taking some of others.

Be on your toes, particularly when a cunning old devil revives from a state of coma, for then he is all set to complete his remaining malicious blueprints, and that too, without even waiting for the right time.

It is a matter of grave concern and not comfort for the individuals, standing at your back are not for your support but had made you their guard.

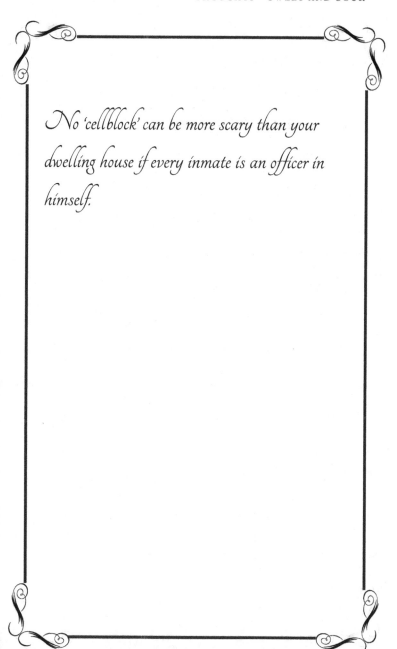

No 'cellblock' can be more scary than your dwelling house if every inmate is an officer in himself.

Worth of all is better understood only if attainments are secured after thorough and a due struggle.

A chatterbox has nothing to hide.

.... and therefore a blabbermouth and the polar is an ideal duo, for they do not suppress anything from each other.

Some could call spade- a spade, simply because there was never any fear to lose "all".

Narrow mind think broad for it had been encyclopedic before embracing the mindset.

It is not empty but scheming mind that is devil's workshop.

Some find first in every love but do not get even the last.

The so called blind supporters are always the first to blow the trumpet of your countdown.

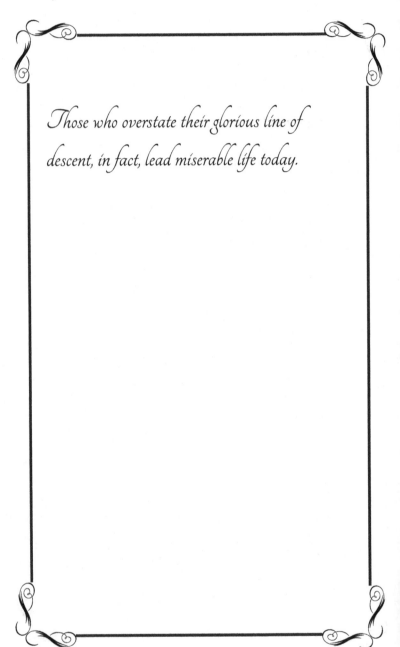

Those who overstate their glorious line of descent, in fact, lead miserable life today.

Words like 'glorious' and 'past' always go hand in hand.

We continue to live only to wait for the day when we meet our loved ones whom we have lost.

By the time you realize you have been fooled by everybody it is very late to rewind your lifecycle. And therefore left with no option but to wait for the second innings if granted by Almighty.

We do not give even the 'thought' a 'like', simply for it speaks of the bitter truths-wish could have escaped by never embracing them.

Those who hurry initially to enter the subsequent age, often land the last aforetime.

Some get singled out, for they emphasized of being single for long.

No greater cruelty can ever be than the one, when you do not get what you deserve but every time given the impression that it is underway and soon will be yours.

Upbringing of offsprings become relatively a greater uphill task, especially when both the parents are brought up under different schools of thought.

Many never get even recognized but some continue to live with the impression that one day 'seniority' will be established outside their unit as well.

A big salute to those who spend maximum of their precious life time with a 'conniver' known for the sincere efforts he put in to earn a name- 'Plotter'- who never sits idle and become and expertise for holding ill wills towards all excluding himself.

'Happiness' can only be found "within".

Uphill is the journey with the one, not down to earth.

It is the former generation that ascertain 'the surge of instabilities' during theirs, do not creep into the latter ones.

Sweet remembrances keep you going.

Some are able to survive only due to the 'fittest'.

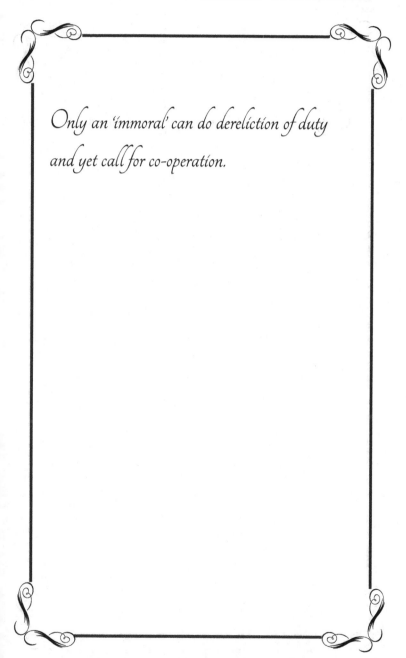

Only an 'immoral' can do dereliction of duty and yet call for co-operation.

It is the 'concern' for others that take you out safely from every "eddy".

The one with fixation for 'cleanliness' is a misfit beyond doubt.

The definition of 'true love' differs from person to person.

Only parents can be taken for granted.

None is jack of no trade.

It may be a 'non serious' who is taken serious of all one day.

Be careful of the people who play life alike the game of chess for not to win but to defeat others.

Only devils play and call it a 'game'.

Reward for good and bad actions always come in multiples if not paid instantaneously and therefore is relished eventually by many including those who had been associated with you.

One can remain out of the mind of the evil spirits by being out of their sight also.

In real life game too, it is the opponent that keep you on your toes throughout.

'Weak' feel strong for they have excessive faith in the weight, a paper carry.

May be the one who never could express was your true love.

It is the evil that perish the devil despite its off-times effort to exhibit its powers.

Cyber age generation often misinterprets the privileges for his rights and vice versa.

It is better to shed the idea of a 'joint unit' if every dweller being to stipulate 'space'.

No priority could ever be to the parents other than the survival of their younger ones provided they themselves had survived the 'ground realities'.

Despite all, blood identifies its group one day.

Alike two sides of a coin, both mind and heart too, speak differently.

The wider publicity of any product depends upon its uselessness, relatively.

One enter every time into the wrong age for the ripples of panic swamp the mindset in the first go.

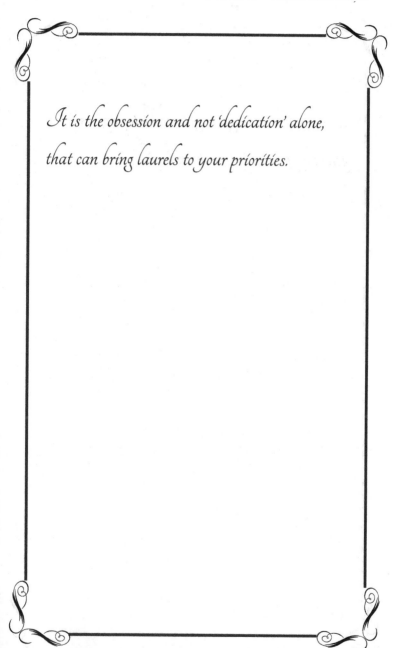

It is the obsession and not 'dedication' alone, that can bring laurels to your priorities.

..... one soul is enough to get the history of its genealogy included in the annals.

Avoid those who make you daydream, only to make theirs come true.

Maintain a reasonable distance from those who deploy you in the name of 'help'.

The priority to make your stay more hellish day by day, depends on the distance your co-passengers are at.

Eyes that bring tears in no time for seeking favor can only be of master hypocrites who often pretend weak/'ultra sensitive' and bring each fall of their tantrums quite comfortably.

"Barriers" never let you run free.

Willfully letting someone consider you as a 'time pass' for years together, can only mean that unconsciously soft corner had developed which never simply be able to soften the other's.

Underserved "position" leave 'some', never to recover from its hangover even years after since it was taken away.

Only the ones with filled in bellies can afford "religion".

Over- ambition leap over fulfillment of due ambitions even.

Only when told the rules in advance can it be called a 'fair' game.

Hats off with eyes filled in tears to those exceptionally optimistic people who continue with all might hitting their head against a rock with the hope to smash it in part at least, one day.

No wordbook writes that 'cheap' carry zero value.

Even "time" fail to heal up 'wound' the heart ever was inflicted upon.

Those from whom 'destiny' snatch love and affection much before they gain consciousness, are the only worst affected lot that fall easy prey to all, every time they come across a mirage in the form of a ray to get the same.

Nowhere is inscribed that one is free to make any of his bestowed blessing into a 'curse' to others.

One may play his due innings provided he fill the corner with pebbles in place of emotions.

One wrong decision for not recognizing the best suitable life long companion deliberately, simply because of the myth that it is found only after a through search, force you ultimately to live all alone, for you get the same treatment by the latter one day.

'No other than the one who enjoy peace of mind, can be called the 'Richest of all'.

The only way to get rid of a bad habit is to give it up 'once for all'.

Self is the best mockery.

It is only the 'time' that matters for no story ever remain unrevealed of its suspense, provided one do not run out of patience too.

Sustained magisterial nature can only generate irreversible 'hate'.

The support can never come under scanner provided those who stand with your evil tell their interests within time.

'Gifts' of GOD are priceless.

Even the remembrances of your loved one's,

surrender one day, for not able to continue

compensate of the absence anymore.

Some' get used to, being used by few to the extent that depression crawls in their personality when they are given a second thought.

Some short associations last very long.

Every day is like a fleeting phase from where you come out a transfigured person daily.

Every 'beginning' comes with an 'end'.

Hate loses all.

Oh GOD! Liberate us from those who only excel in making one fall in their 'mouse trap' again and again.

If short naps often take you to the world that you miss for very long of love and affection, can only mean that going back home is at hand.

"Curse" is blessed enough to make the 'genealogy' a history.

One may preserve you heart not to further and this time to pieces provided you are not bid bye specially at the time he last see you off.

Only the 'curse' carry the blessing to make you life as per its definition.

The proportion of 'pain' and its rewards vary miraculously amongst all.

Short term benefits fetch long term repentance.

Memories of the past fill sweet in your sour present.

The compliments should not drive you away.

The only optimistic is the person who continues posing as an idiot in the hope that at least, one will take him serious one day.

The true and best friend of yours can only be you.

One side adjustment of 'nature' simply will never work.

Harsh words never die whereas 'good' live after that.

Mother's love is supreme.

Parents never leave in the lurch.

A journey into the beautiful past rejuvenates and readies you for the future.

Better throw out prior, the ones with history to use.

It may also be the 'soul' that will ascertain whether it would be comfortable/fit with this body or not, later on.

Putting a line or two in black and white on your understanding of human relationships is also one way of giving an outlet to your feelings.

Ones with 'obsession for cleanliness' is the worst company to be in association.

It is the dread 'within' of cut to a size that keeps you always enwrapped of you are at heart.

Close relations take you far, proportionately.

The outlet of 'emotions' keeps you in good proportions.

Only 'reminiscences' will bear the testimony of your existence.

The mindset to relish undeserved bread is bound to starve the generations later.

Only 'a few' get recognition thanks to the adversaries.

Each thinks other 'unworldly', the mostly.

The term 'cakewalk' had never been in the dictionary of 'all'.

Life 'after' should be better... and thus, the cycle moves on and on.

Disproportionate words of praise may be a 'mouse trap'.

Active opponents are less harmful than the passive ones.

Putting anything in black and white and
passing the same to the person it directly refers to,
should make them revisit/ review things afresh,
at least from that moment onwards.

It is the conscience that makes a guilty feel as if he is the one for the center for discussion around.

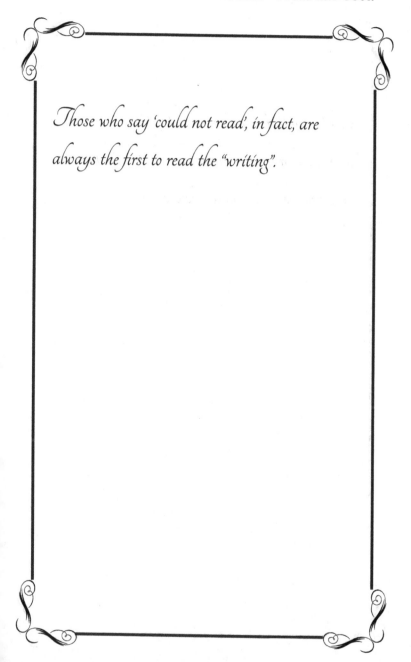

Those who say 'could not read', in fact, are always the first to read the "writing".

Most pitiable are those distant relatives who also eyed on your material assets, for the nearest ones grabbed them much before.

Only a 'lateral entrant' can practise and advocate the back entry as the 'main' and vice versa.

'Time' and 'Tide' wait for the one who do not wait for either of them.

A thorough discussion of different re — interpretations by ill —willed mindsets, does due justification in the process.

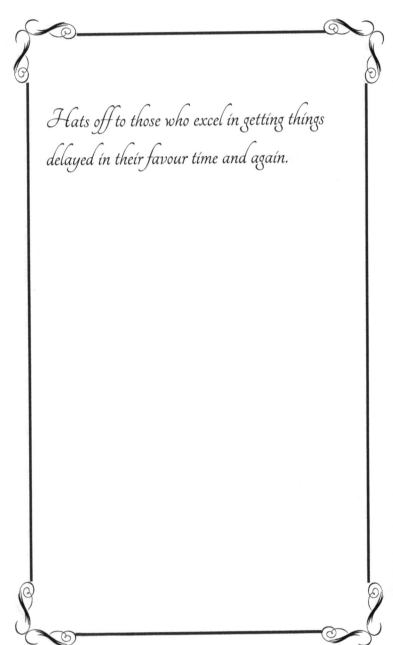

Hats off to those who excel in getting things delayed in their favour time and again.

The final 'nail' is often put in, by the most beloved.

The term 'courageous', attributed to the one who does not hide from any — but never to the one who does not reveal the same even to himself.

Only those standing beside 'the chair' are the ones who keep reminding the occupant of the privileges attached to it — interests better known to them.

Only weak need detachments.

An 'unattached' is never at rest.

'Work shirker' and concession seekers had all time been the most sought after to the stakeholders in a 'set up'.

'Others' think that you got more what you otherwise deserved.

Very pitiable are those distant relatives who also eyed on your material assets, but the nearest ones grabbed them much before they could.

Some find proportionate opportunity, when are sought 'help', to settle scores from the person in question.

"Off springs" teach what would have labeled

you as 'good parents'.

It is always the other partner in life who claims throughout, to have made your house a 'home'.

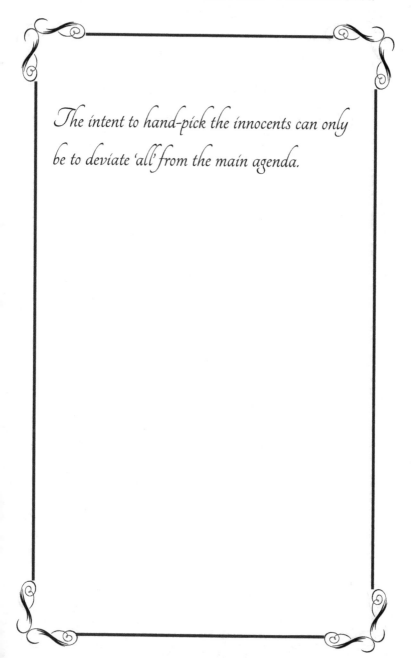

The intent to hand-pick the innocents can only be to deviate 'all' from the main agenda.

Outright show of 'strength' also speaks of its "countdown".

The last platform we all land one day may be near but quite far from "all".

It may be a sheer myth that those who annihilated were in no relation with you, for the association could have been for ages.

They who remain blind and dumb to 'wickedness' have never been spared too.

It is the soul that search, but not all are able to find its true mate.

Only a 'nefarious' go to any extent and can remain undetected.

An 'untold' may also have been very clear of his prime concerns.

The enactment of an 'angler' can be justified by the one who leads a 'free life'.

Failure for not been able to win 'one' makes some swear defeat "all".

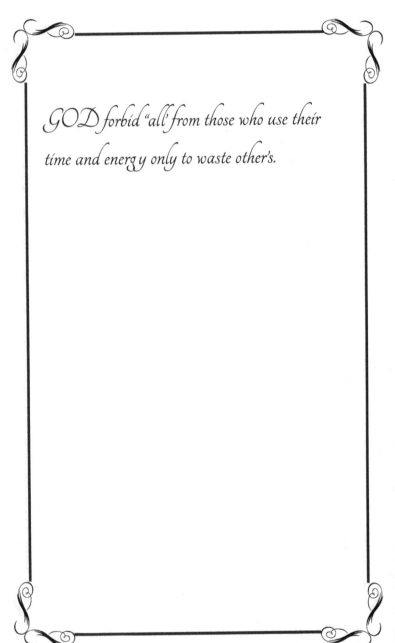

GOD forbid "all" from those who use their time and energy only to waste other's.

One will never be absolved by 'self-esteem' for taking the same granted and putting it at stake again and again.

It is the torment 'within' that makes you a 'man of letters'.

Consensus on 'equality' had been the all-time bone of contention to all.

Uphill is the journey with the one not down to earth.